BP PORTRAIT AWARD 2010

D1098329

National Portrait Gallery

Published in Great Britain by
National Portrait Gallery Publications
National Portrait Gallery
St Martin's Place, London WC2H 0HE

Published to accompany the BP Portrait
Award 2010, held at the National Portrait
Gallery, London from 24 June to 19
September 2010, the Usher Gallery,
Lincoln from 1 October to 14 November
2010 and the Aberdeen Art Gallery from
27 November 2010 to 22 January 2011.

For a complete catalogue of current
publications please write to the address
above, or visit our website at
www.npg.org.uk/publications

ISBN 978 1 85514 424 8

A catalogue record for this book is
available from the British Library.

10 9 8 7 6 5 4 3 2 1

Head of Publications: Celia Joicey
Managing Editor: Christopher Tinker
Project Editor: Robert Davies
Design: Anne Sørensen
Production: Ruth Müller-Wirth
Photography: Prudence Cuming
Printed and bound in Italy
Cover: *Blue* Coco by Shaun Downey

Supported by BP

CONTENTS

DIRECTOR'S FOREWORD 4
Sandy Nairne

SPONSOR'S FOREWORD 5
Tony Hayward

THE SECRET LIFE OF PORTRAITS 6
Rose Tremain

BP PORTRAIT AWARD 2010 13

PRIZEWINNING PORTRAITS 14
Daphne Todd 15
Michael Gaskell 16
David Eichenberg 17
Elizabeth McDonald 18

SELECTED PORTRAITS 19

BP TRAVEL AWARD 2009 74
Isobel Peachey

ACKNOWLEDGEMENTS 79

PICTURE CREDITS 79

INDEX 80

DIRECTOR'S FOREWORD

The judges were presented with a considerable challenge in 2010, as once again a record number of portraits were submitted – with an increasing number coming from overseas. Judging anonymously forces each jury member to confront what they believe makes an outstanding portrait. What is the place of technical accomplishment – whether in broader, more expressionist styles or in tighter, more realist approaches? What is the importance of narrative – and of symbolic references and the placing of significant background elements or objects? How can one best judge the likeness – particularly when most of the subjects are the artists' family or friends and relatively few are subjects chosen through a commission? What is the impact of the overall structure – of picture-making in the larger sense: handling shadow and light, structuring of parts and positioning of figure and face, application of colour and texture? All these questions combine in debate, discussion and opinion, and also in disagreement. By stages, fifty-eight portraits emerge as the final list for this year's exhibition, and then comes agreement on the prizewinning work made by a young artist, and finally the three shortlisted paintings.

The whole BP Portrait Award exhibition is a glorious celebration of contemporary painted portraiture, whether through the 2,177 submitted works, the discoveries from the previous year's BP Travel Award winner, or the commission offered to the overall winning artist. This year, however, marks a new departure. In recognition of BP's position as a sponsor of the Cultural Olympiad, the 'Next Generation' project has been developed, which connects previous prizewinning artists with talented young people, so that they can extend their skills in portraiture and be inspired to contribute to an ever more creative future in this country.

I am very grateful to BP for their continued support for the competition, exhibition and the Travel Award, over more than twenty years. This is an outstanding example of sponsorship that really adds to the arts, and my thanks go to Ian Adam, Jayde Card, Peter Mather, Des Violaris and other colleagues at BP, as well as to Tony Hayward, Group Chief Executive.

Sandy Nairne
Director, National Portrait Gallery

SPONSOR'S FOREWORD

The National Portrait Gallery is home to the world's largest collection of portraits, and BP has been the Gallery's proud partner and supporter of the Portrait Award for the past twenty-one years.

The 2010 BP Portrait Award attracted 2,177 entries, from sixty-nine countries. I would like to thank and congratulate all the artists; as always, the quality of entries was outstanding and it is this talent that has enabled the Award to continue to grow in stature and popularity.

This year, I am delighted to announce an extension to the programme. We are introducing a series of summer schools for 14- to 18-year-olds who wish to expand their knowledge of portrait painting.

Of course, none of this would be possible without the vision of the team at the National Portrait Gallery. Their efforts and dedication have turned this into one of the most prestigious awards of its kind. I would like to thank everyone for ensuring the continued success of the BP Portrait Award. This exhibition is testament to the great talent that the Award uncovers from around the world.

Tony Hayward
Group Chief Executive, BP

THE SECRET LIFE OF PORTRAITS

Rose Tremain
Novelist

In the small London house where I grew up, a very large portrait of my father, then aged about forty, hung on the dining room wall. Its colour tones were greys, yellows and umbers. The picture must also have given some prominence to my father's dark, abundant and shiny hair. I don't remember it in great detail. Perhaps this is because, in the rigidly observed seating hierarchy of my small family, I was always positioned with my back to the wall on which the portrait hung.

Perhaps, also, it's because, after my tenth birthday, when my father left our home and divorced my mother, he took the portrait with him and I never saw it again. Yet among the competing imagery of my childhood, it remains solidly there: Dad's portrait, a picture of a hauntingly good-looking man, who abandoned the life I was in and never rejoined it; the representation of a ghost. I've often wondered who commissioned this portrait and why.

My father was a moderately successful playwright and theatre director, whose most lasting claim to fame turned out to be his 'discovery' of the then-unknown actress, Mary Ure, whom he cast as the Virgin Mary in an admired production of the York Cycle of Mystery Plays in 1951.

Did the relative triumph of this event, for which he was awarded the OBE,

lead my father to commission a portrait of himself – before his looks faded, before his career began to slide? Did my mother commission it, out of doomed affection for him? Or did the artist (whose name I don't recall, or possibly never knew) come to him and ask him to sit? In other words, did the picture exist because of an act of vanity, an act of adoration, or a plain and simple commercial transaction?

There is always a reason why each and every portrait exists and I'm very interested in what some of these reasons might be.

In the seventeenth century, we know from Pepys's diary that, after the restoration of King Charles II in 1660, members of the class to which the diarist belonged (the aspiring middles and upper-middles) were extremely eager to commission noble likenesses of themselves and their families to hang above the mantel. Pepys (1633–1703), who habitually tended to put his own selfish desires before those of his wife, Elizabeth (1640–69), in fact commissioned her portrait first – from an artist referred to only by his surname, Savill.

'To the paynters,' Pepys writes, 'and there she sat … and I stood by and did tell her some little things to do, that now I think her picture will please me very well.' This narration conjures a lively image of the bossy husband

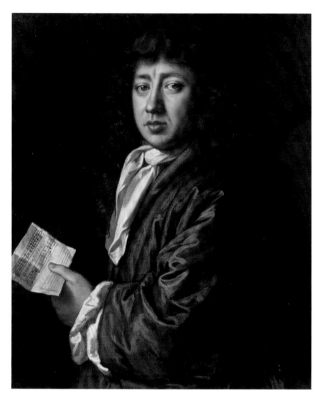

Samuel Pepys (1633–1703) by John Hayls, 1666 (NPG 211)
Oil on canvas, 756 x 629mm (29³/₄ x 24³/₄")

arranging and rearranging his wife's appearance to suit his preferences, but the tone is fond. Pepys even allows the artist to paint Elizabeth's dog, 'which made us very merry'.

Pepys had good reason to spend money on portraits. He was a rising man. He knew that his life might be short, but that a picture would lend it significance while it lasted and prolong his memory beyond the grave. More than this, men such as Pepys, who worked in the Navy Office and were confidants of the King, would have had very frequent sight of the ever-proliferating portraits of

Charles II which adorned the rooms and galleries of Whitehall, and been impressed by what they captured.

For surely, in the pictures painted of King Charles in the ten years that followed the restoration there resides an *essence* of kingship, a kind of *beau idéal* of monarchy, never quite matched before or since. Charles's sombre but still-beautiful features, the waterfall of black curls, the exquisite lace at his throat, the satin and velvet of the royal vestments inspired the artists of the day to some memorable work. And Pepys no doubt asked himself: if the essence of a sovereign

could be rendered so exquisitely in oil paint, (as, for example, by the Pieter Nason portrait, 1664) then why not other essences, more modest of course, yet manifesting nonetheless a noble singularity, a proud and distinct humanity?

It is this kind of yearning – to get a proper place in the world and give his life some substance and seeming permanence – which possesses Robert Merivel, the hero (or more correctly, the anti-hero) of my novel *Restoration*, set during the years 1664–7.

Forgotten by King Charles after a brief stint as the king's 'fool' at court, languishing alone and bored on his Norfolk estates, Merivel decides, not to commission his own portrait, but to attempt to become an artist himself. He believes that if he could learn to paint, he might arrive at 'compassion' (what he actually means is empathy), and that compassion will lead him onwards towards some inexpressible kind of enlightenment. These sentiments are dismissed by Merivel's Quaker friend, Pearce, as 'pagan, freakish piffle', but Merivel clings to them, orders an artist's smock and a floppy hat, canvases, pigments and brushes and sets about his task with his characteristic over-enthusiasm, only to understand very quickly that his work has no value whatsoever.

It's at this point in the story that Elias Finn enters Merivel's life. Finn, Merivel writes, 'describes himself as a portraitist, but leads, I discover, an almost mendicant life in the shires of England, going on foot from one great house to another, begging to paint its inhabitants.'

Hired by Merivel to help him progress in his new vocation, Finn has, in fact, understood the age slightly better than his employer. Merivel mocks the artist's poverty, but Finn knows that, in the end, he will find enough willing sitters to survive as a portraitist. Smart society is once again engaged in an annihilating scramble for personal advancement and public recognition; the portrait is a necessary fashion accessory along the route and there are only so many portrait painters to go round.

Much later in the story, after Merivel's fall from grace and during his long struggle to make sense of his life by an attempted return to his first vocation, medicine, Finn executes a portrait of him, and this confrontation with his own face brings about a rare moment of stillness amid my hero's restless strivings. In its essence, *Restoration* is itself a 'portrait'. It's a long study of how one man arrives, by very slow degrees, at wisdom and understanding. Finn's painting is one landmark along the way. 'I watched the picture carefully,' writes Merivel, 'for any signs of fiction and untruth. But I am glad to say there were none. Behind my head is no imagined Utopia.'

Merivel manages to hold a fairly steady gaze upon his own features, but seeing one's face 'as it is' may often be shocking. Pictures (both portraits and photographs) fling back at us details the mirror somehow fails to point out. As we age, we age *more* in pictures than we do day by day, for the simple reason that time continues its relentless work between the taking of one set of pictures and the next, but our self-image remains linked to

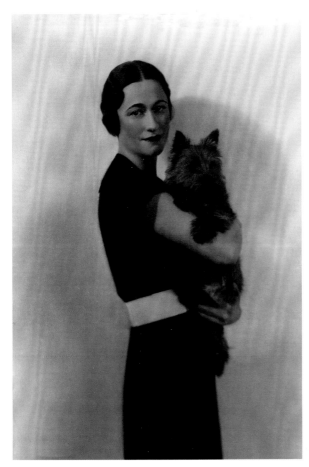

Wallis, Duchess of Windsor (1896–1986) by Dorothy Wilding, 1935 (NPG x25936)
Toned bromide print, 291 x 202mm (11 1/2 x 8")

the former set. (Perhaps Oscar Wilde came by the idea for *The Picture of Dorian Gray* from this realisation?)

As a writer who works very frequently from visual material of all kinds, I have been fascinated to chart the passage of particular lives from an assemblage of portraits and photographs. In my long short story, *The Darkness of Wallis Simpson*, the narrator is Wallis herself, but this is Wallis in her eighties, a Wallis of whom no single picture exists, for the simple reason that nobody was allowed to visit her. In old age, Wallis Simpson (1896–1986) became a prisoner of her house in Paris, kept out of sight by her 'guardian', Maître Suzanne Blum, in such an isolated state that from time to time rumours spread that the Duchess was already dead.

In the middle of her life, however, from the day her affair with Edward, Prince of Wales began, Wallis was one of the most photographed women in the world. To write my story – which turns on the invented trope that the ageing Wallis can remember almost everything about her life *except* the momentous fact of her relationship with the man who gave up his empire for her – I spent hours looking at Wallis's changing face.

At the time of her rise to notoriety, most descriptions of her were unflattering. She was described as 'mannish', 'vulgar', 'coarse' and 'too American'(!). It was she who immortalised the idea that 'you can't be too rich or too thin'. She seems to have lived mainly on a diet of dry martinis and green apples and resorted readily to cosmetic surgery to keep her cheekbones sharp as she aged. She was, in fact, a significant precursor of the cult of the size zero model, which is proving to be so deleterious to the way women think about their bodies in today's world.

There are many reasons to feel hostile towards Wallis Simpson, or at least towards the values she espoused. And yet, the more time I spent looking at Wallis's pictures, the more beautiful she became to me.

I'm sure there's some kind of *syndrome* to describe this, an author's gradual and illogical attachment to his or her subject's physical attributes. But still, today, I can't look at a portrait of Wallis Simpson without finding some beauty in it. You could argue, however, that because what my story records/invents are Wallis's internal confusions, longings,

sorrows and moments of joy, it is in fact her humanity and not her face that moves me. And I think we're at the core of something here. We've arrived at one definition of the portrait painter's prime aspiration: to record *without words* the internal life of the individual.

Like Charles II, Wallis Simpson was defined physically in her pictures by what she wore and by her immaculate grooming. In most portraits of her, the background is kept simple, so as not to distract from the magnificence of her gowns and jewellery, and from the enviable lustre of her hair. Sometimes, however, she's pictured beside some sumptuous piece of furniture or an oversized flower arrangement, and these props function as symbols of her life, or at least of her lifestyle.

Whatever is in the background of a portrait – the small details that may at first go unnoticed but soon congregate into sharp focus – can, if well chosen, add brilliantly to the viewer's perception of an individual.

In Derry Moore's adroit colour print of Alan Bennett (b.1934), photographed in 1992, the chosen background is full of noisy variety. It *talks* to you. Moore has positioned Bennett in front of a gilded classical mirror, whose surface is almost entirely covered up with cards and photos. These range in subject from a young W. H. Auden, a cobbled Paris street, a provincial playhouse, a boy (looking rather like the young Picasso) holding a white dog, a theatre programme, a wrought-iron staircase to assorted snaps of Bennett himself with relations or friends. In Bennett's solid,

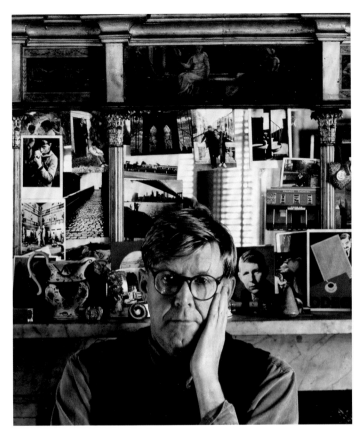

Alan Bennett (b.1934) by Derry Moore, 1992 (NPG P525)
Colour print, 347 x 297mm (13⁵/₈ x 11⁵/₈")

unmoving face, we can recognise his trademark outward persona, the 'wryly amused Northern stoic'. But near Bennett's head, above and around the unchanging blond hairline, the collage of pictures suggests to perfection the writer's voice talking and wondering, selecting and sifting; a mind fully alive and curious about the world.

Another writer's portrait I admire is Delmar Banner's picture of Beatrix Potter (1866–1943), painted in 1938.

This, in a clever sleight of hand, is Miss Potter *as field vole*. The artist has integrated the subject cunningly and completely with her fictional world. It's as though the middle-aged author had just popped out of a ripening cornfield to take a sniff at the sheep-shearing contest going on behind her. At any moment, she will scuttle away, in her camouflage colours of brown, green and grey, but with her wide-awake, inquisitive eyes alert to what has been planted in Mr McGregor's vegetable garden,

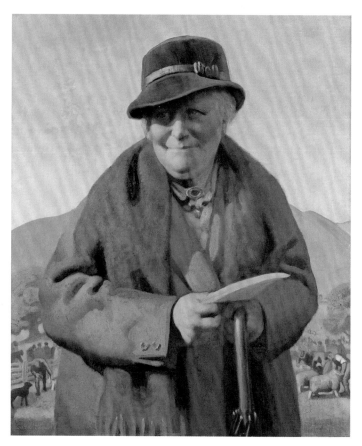

Beatrix Potter (1866–1943) by Delmar Banner, 1938 (NPG 3635)
Oil on canvas, 749 x 622mm (29$^{1}/_{2}$ x 24$^{1}/_{2}$")

there to wreak her abiding havoc down the centuries, impervious to changing weather and fashion: part of Nature herself.

And this, of course, is what we all want when we agree to sit for a portrait. We want to become part of what is going to last. Writers, kings, courtesans and navy clerks, we all crave our own immortality.

No doubt my father craved it too, when he sat for the picture that hung in our London dining room. But did he get it? Did that picture actually exist? Or is it – like Wallis Simpson's forgetting of the thing that was most precious to her – just another of my mind's provocative inventions?

BP PORTRAIT AWARD 2010

The Portrait Award, in its thirty-first year at the National Portrait Gallery and its twenty-first year of sponsorship by BP, is an annual event aimed at encouraging artists to focus on and develop the theme of portraiture in their work. The competition is open to everyone aged eighteen and over, in recognition of the outstanding and innovative work currently being produced by artists of all ages working in portraiture.

THE JUDGES

Chair: Sandy Nairne,
Director,
National Portrait Gallery

Sarah Howgate,
Contemporary Curator,
National Portrait Gallery

Ishbel Myerscough,
Artist (first-prizewinner in 1995)

Christine Rew,
Art Gallery & Museums Manager,
Aberdeen

Sir David Scholey CBE,
Senior Adviser, UBS Investment Bank

Des Violaris,
Director UK Arts & Culture, BP

THE PRIZES
The BP Portrait Awards are:

First Prize
£25,000, plus at the Gallery's discretion a commission worth £4,000 to paint a well-known person.
Daphne Todd

Second Prize
£8,000
Michael Gaskell

Third Prize
£6,000
David Eichenberg

BP Young Artist Award
£5,000
Elizabeth McDonald

PRIZEWINNING PORTRAITS

Last Portrait of Mother
Daphne Todd

Oil on wooden panels,
650 x 920mm (25$^{1}/_{2}$ x 36$^{1}/_{4}$")

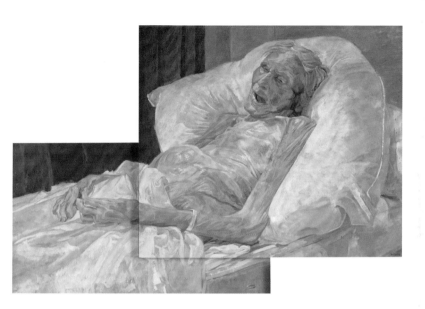

Harry
Michael Gaskell

Egg tempera on wooden board,
290 x 205mm (11$\frac{1}{2}$ x 8")

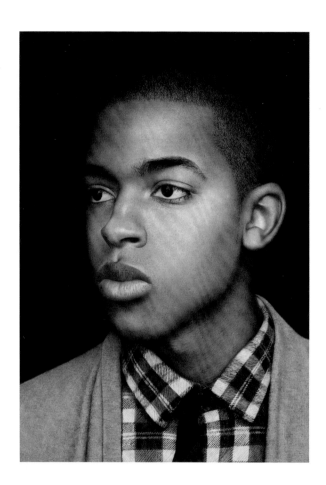

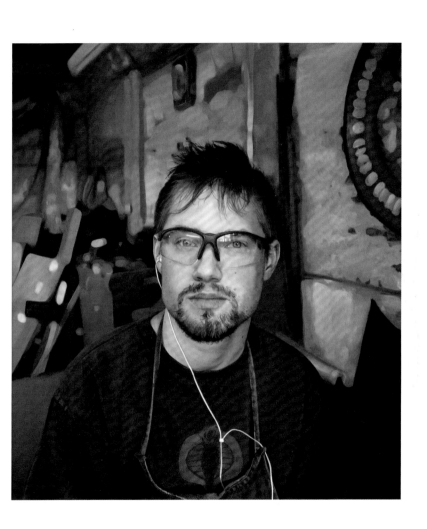

Don't Be Too Serious
Elizabeth McDonald

Oil on canvas,
635 x 432mm (25 x 17")

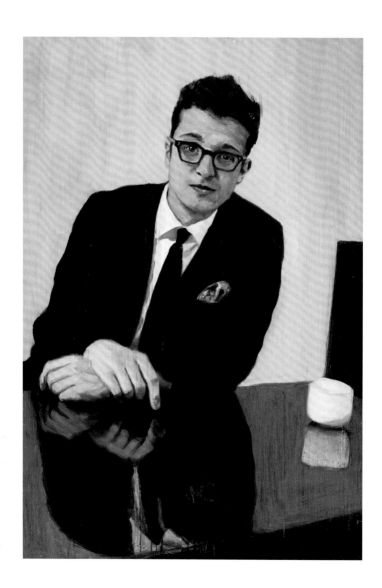

SELECTED
PORTRAITS

Dan
Mary Jane Ansell

Oil on wooden panel,
360 x 270mm (14^{1}/$_{4}$ x 10^{5}/$_{8}$")

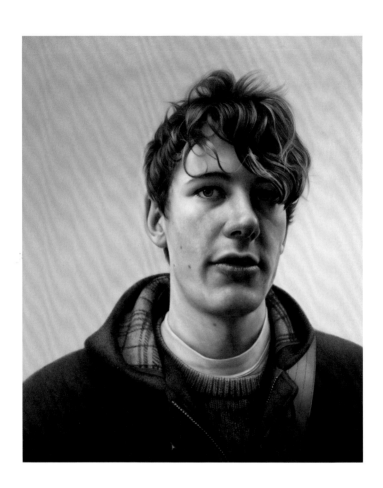

David
Annalisa Avancini

Oil on canvas,
1200 x 1000mm (47$\frac{1}{4}$ x 39$\frac{3}{8}$")

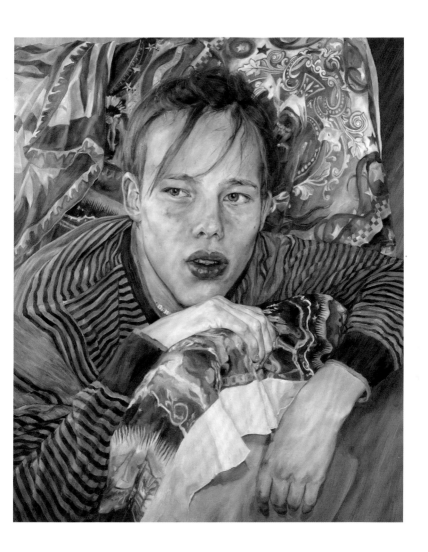

Self-portrait
Robin Bagnall

Oil on hardboard,
725 x 540mm (28$^{1}/_{2}$ x 21$^{1}/_{4}$")

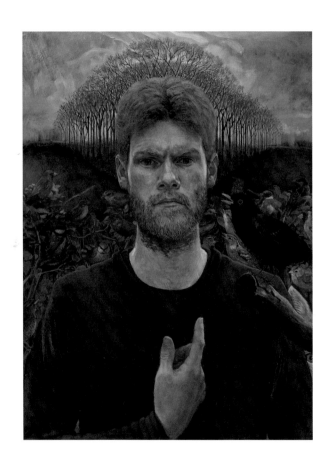

Free David
Paul Beel

Oil on linen,
1500 x 1500mm (59 x 59")

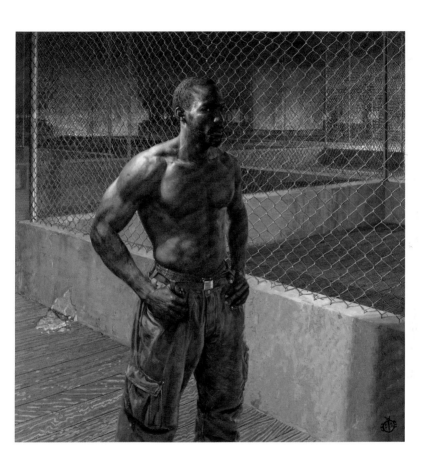

Paul Getty III
Paul Benney

Oil on canvas,
1422 x 1270mm (56 x 50")

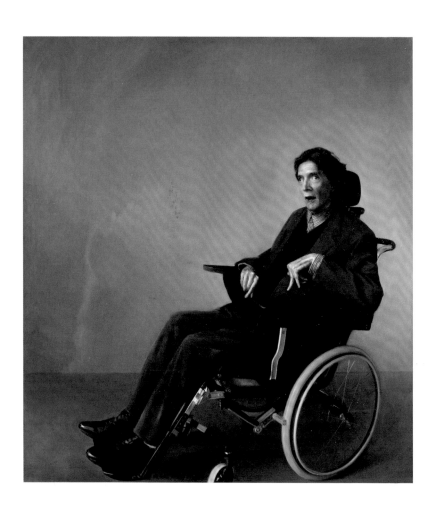

Bloedlyn/Bloodline ... Sannie en Leah
Shany van den Berg

Oil on wooden board,
850 x 550mm (33$^{1}/_{2}$ x 21$^{5}/_{8}$")

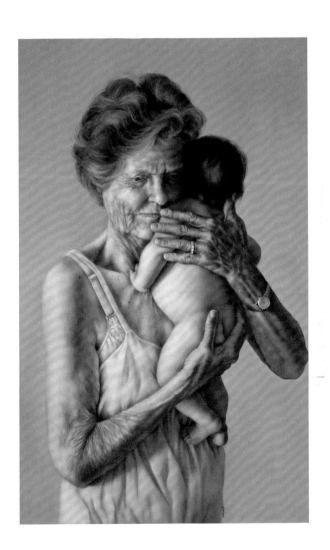

The Player?
Oscar Burnett

Oil on canvas,
1270 x 610mm (50 x 24")

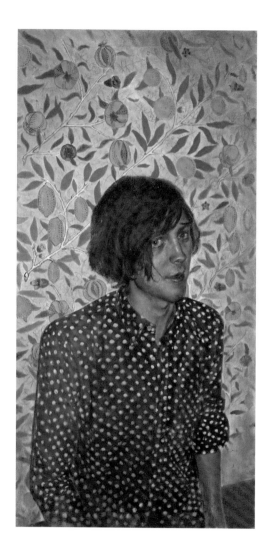

The Rubbish Bin Men
Jason Butler

Oil on linen,
1500 x 1200mm (59 x 47$^{1}/_{4}$")

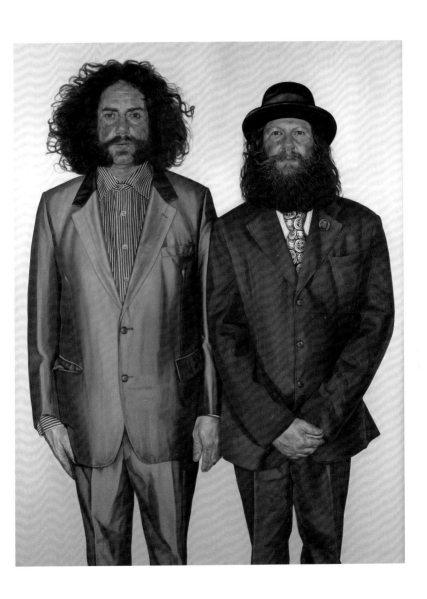

Molly Parkin
Darren Coffield, a.k.a. Darcoff

Acrylic on canvas,
1200 x 1030mm (47$^{1}/_{4}$ x 40$^{1}/_{2}$")

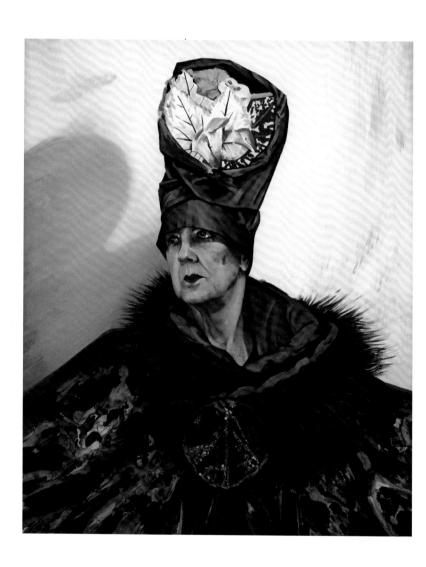

Ciara
Alan Coulson

Oil on panel,
403 x 297mm (15⁷/₈ x 11³/₄")

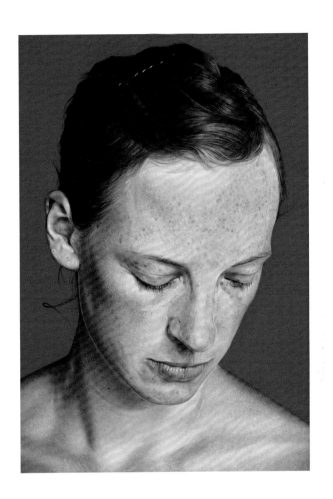

Then and Now
Richard Cross

Oil on hardboard,
305 x 255mm (12 x 10")

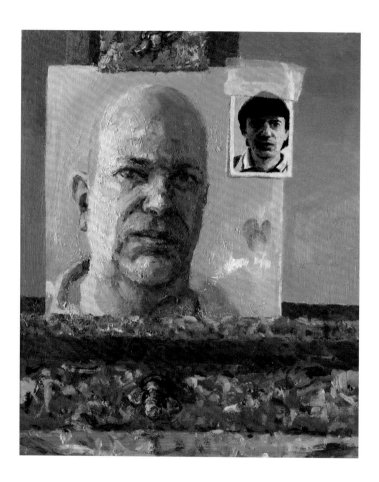

Laurie and the Shed
Tom Dewhurst

Oil on canvas,
1020 x 760mm (40¹/₄ x 30")

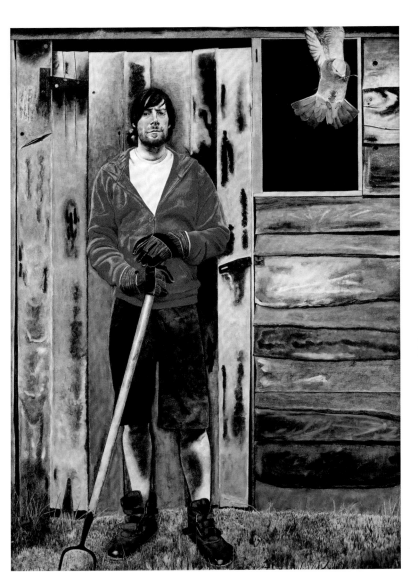

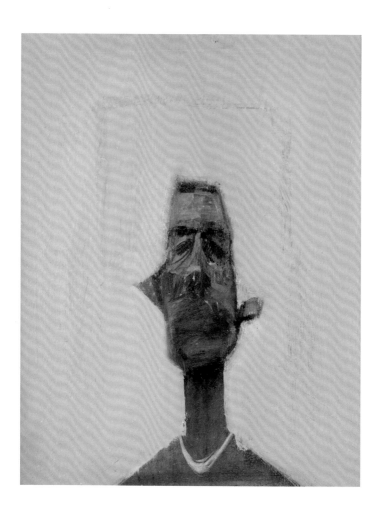

Self-portrait
(with Ribera's Club-footed Boy)
Anna Dougherty

Oil on board,
250 x 200mm (9⁷/₈ x 7⁷/₈")

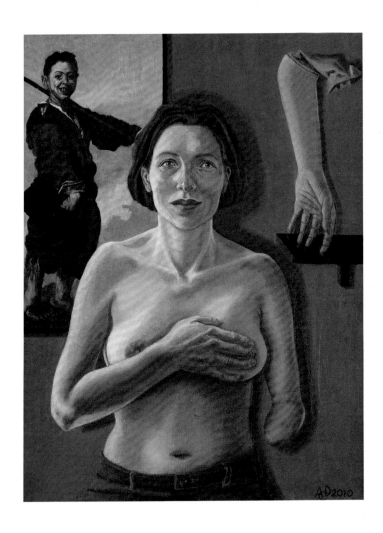

Blue Coco
Shaun Downey

Oil on canvas,
508 x 432mm (20 x 17")

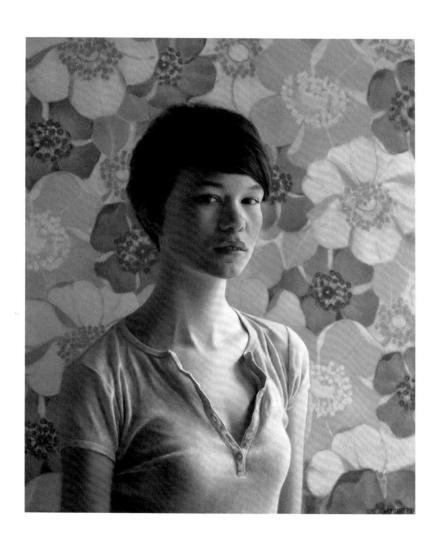

The Visit V (Mary)
Wendy Elia

Oil on canvas,
1300 x 1700mm (51 $^{1}/_{4}$ x 67")

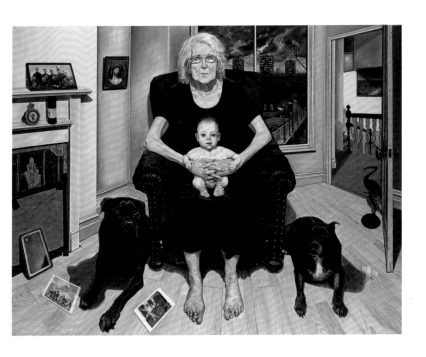

Le Grand Natan
Daniel Enkaoua

Oil on canvas,
2270 x 1825mm (89³/₈ x 71⁷/₈")

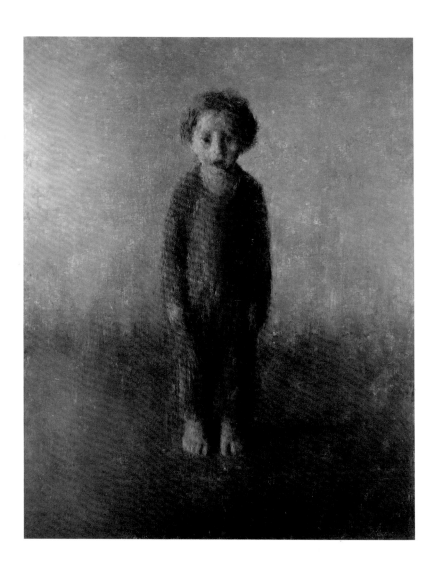

Gillian
Miriam Escofet

Oil on canvas on wooden panel,
700 x 500mm (27$^{1}/_{2}$ x 19 $^{3}/_{4}$")

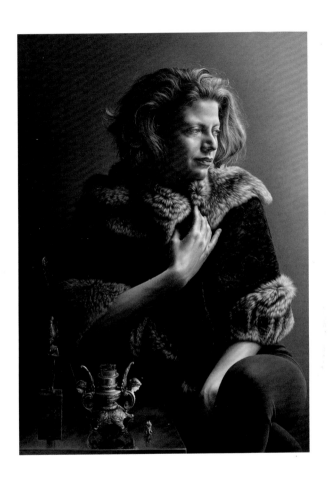

Paul
Nathan Ford

Oil on canvas,
280 x 200mm (11 x 7$\frac{7}{8}$")

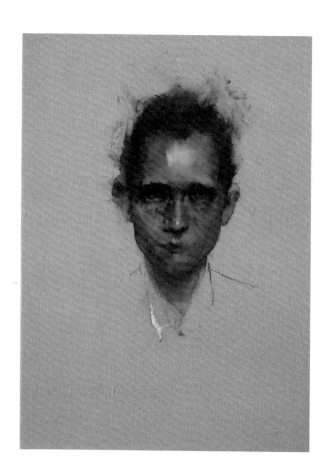

Donovan
Maryam Foroozanfar

Oil on wooden board,
229 x 305mm (9 x 12")

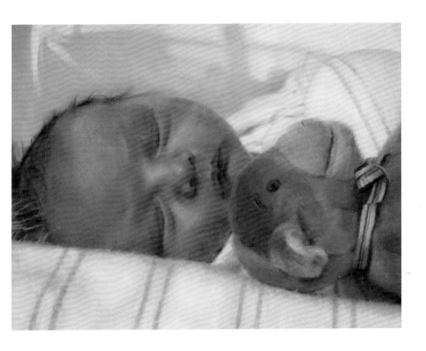

Quena
Eliot Haigh

Oil on canvas,
600 x 500mm (23⁵/₈ x 19³/₄")

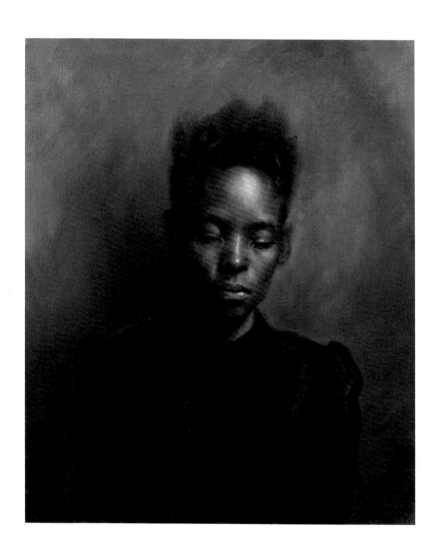

Like Father
Bruce Hanke

Oil on canvas,
381 x 305mm (15 x 12")

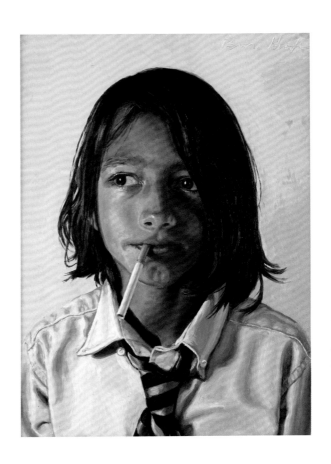

Sandy Watching
Alex Hanna

Oil on canvas,
500 x 760mm (19³/₄ x 30")

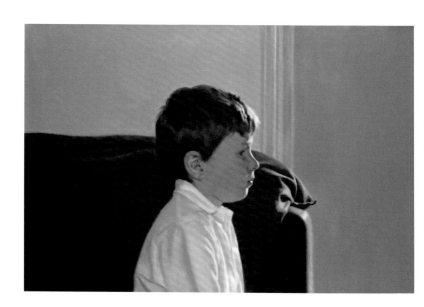

Hoxton Youth
Jason Harper

Oil on canvas,
250 x 250mm (9⁷/₈ x 9⁷/₈")

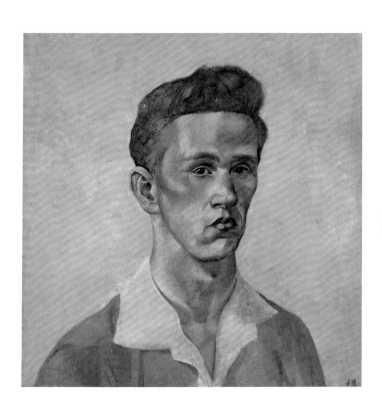

Stationed In Utah
Wim Heldens

Oil on canvas,
305 x 406mm (12 x 16")

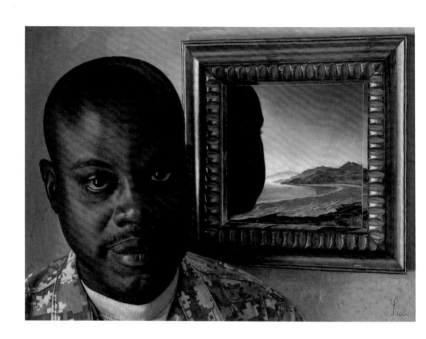

The Hockey Player, Marden Russets
Kaye Hodges

Acrylic on canvas,
1360 x 500mm (53$^1/_2$ x 19$^3/_4$")

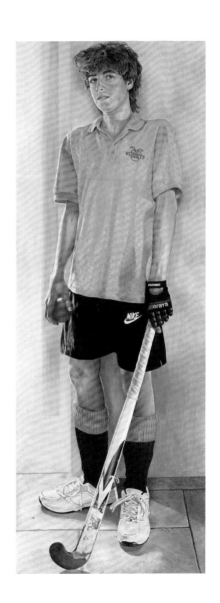

That Sinking Feeling
Mark Jameson

Oil on linen,
1000 x 650mm (39$^{3}/_{8}$ x 25$^{1}/_{2}$")

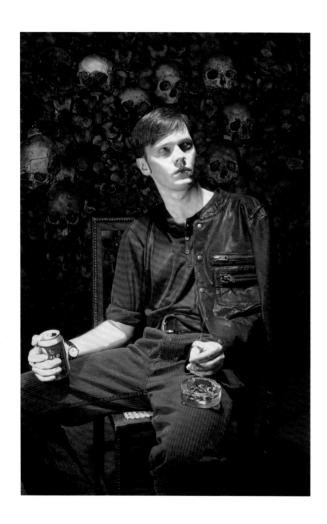

Sentinel
Lyndsey Jameson

Oil on linen,
1220 x 770mm (48 x 30³/₈")

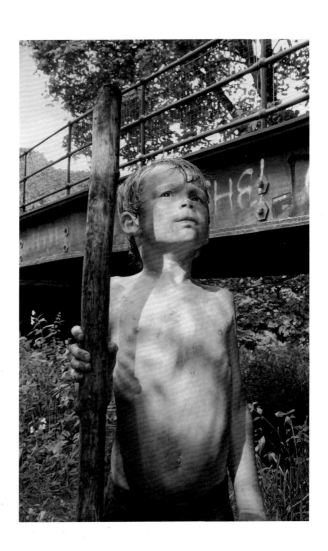

I Went to a Marvellous Party
Diarmuid Kelley

Oil on linen,
1270 x 1016mm (50 x 40")

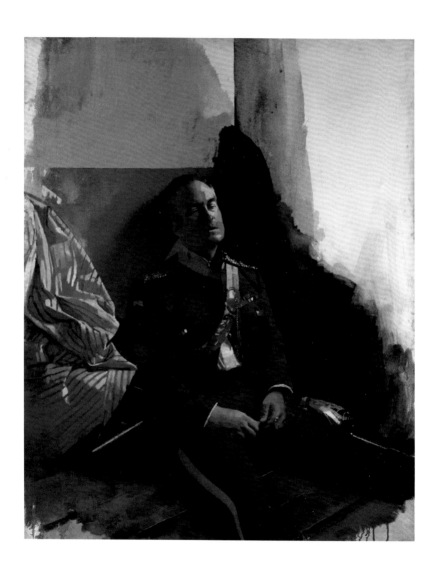

Put the Dog and the Cat in the Poster
Rosy Lamb

Oil on canvas,
600 x 800mm (23⁵/₈ x 31¹/₂")

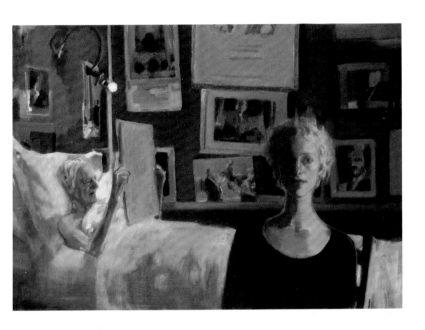

Fathers and Sons
Peter Layzell

Oil on panel,
450 x 450mm (17^3/$_4$ x 17^3/$_4$")

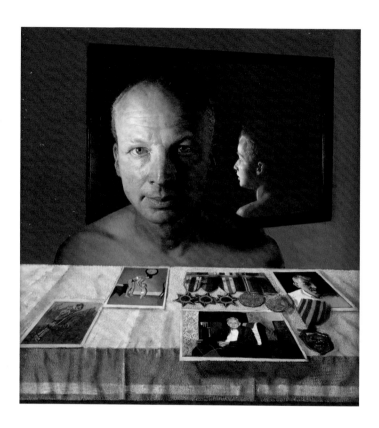

Alan Rickman
Raoul Martinez

Oil on canvas,
978 x 878mm (38$^1/_2$ x 34$^1/_2$")

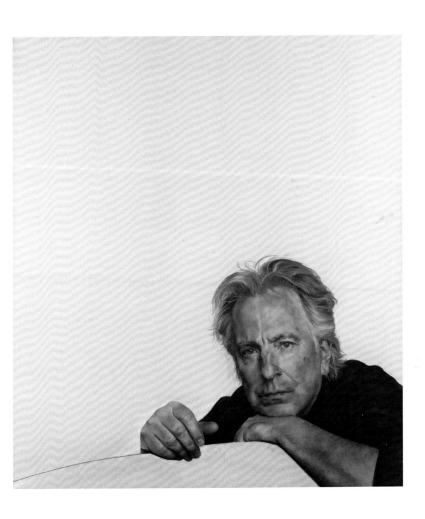

Mayor Boris Johnson
Helen Masacz

Oil on board,
1230 x 930mm (48$\frac{1}{2}$ x 36$\frac{5}{8}$")

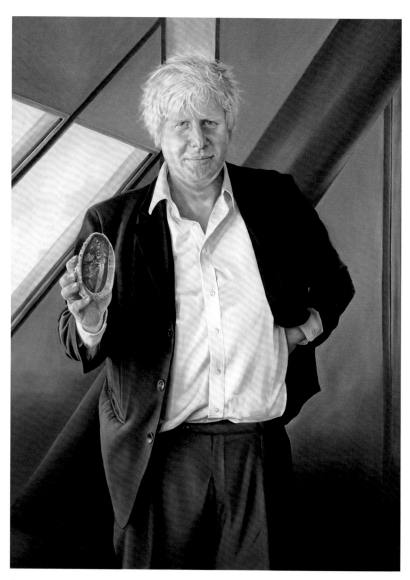

Camellia Japonica
George Melling

Oil on canvas,
1000 x 1600mm (39$^{3}/_{8}$ x 63")

Almus Quartet
Miguel Angel Moya

Oil on canvas,
1620 x 1620mm (63³/₄ x 63³/₄")

The True Self-portrait
Carlos Muro

Acrylic on linen,
2000 x 1800mm (78³/₄ x 70⁷/₈")

From My Soul I Cannot Hide
David Nightingale

Oil on linen,
240 x 270mm (9$\frac{1}{2}$ x 10$\frac{5}{8}$")

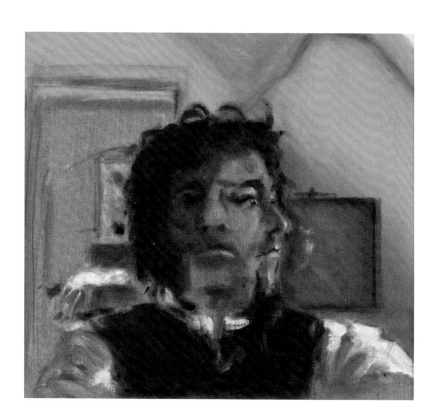

Love Painting – Portrait of my
Wife Jackie and our Cat Amy,
Redbrick Mill Studio
Tony Noble

Acrylic on linen,
1300 x 750mm (51 $^{1}/_{4}$ x 29 $^{1}/_{2}$")

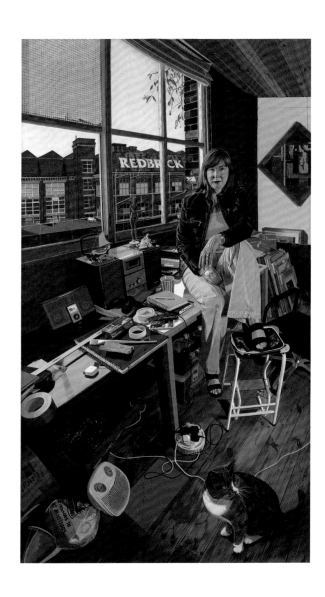

Benjamin Ogbebor (Self-portrait)
Benjamin Ogbebor

Oil on canvas,
300 x 240mm (11⁷/₈ x 9¹/₂")

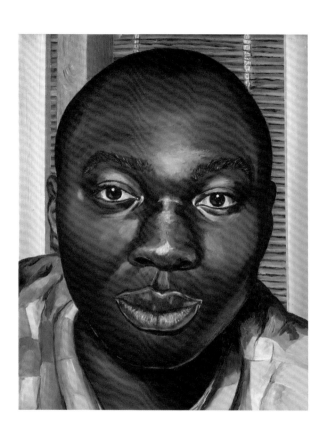

Think Peace
Tim Okamura

Oil and aerosol gold paint on canvas,
1524 x 1016mm (60 x 40")

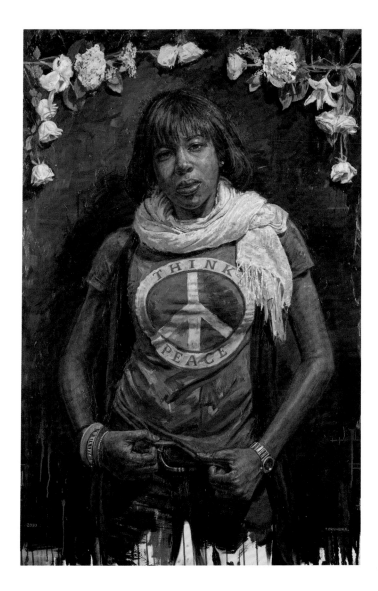

iDeath
Michal Ožibko

Oil with acrylic background on canvas,
2200 x 1700mm (86⁵/₉ x 67")

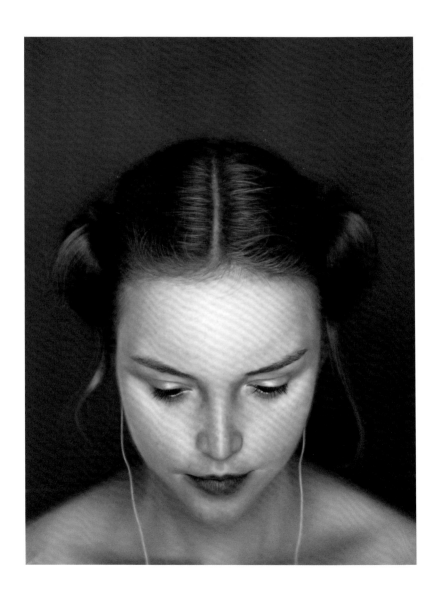

Lila Pearl
Thea Penna

Acrylic on canvas,
505 x 505mm (19$^{7}/_{8}$ x 19$^{7}/_{8}$")

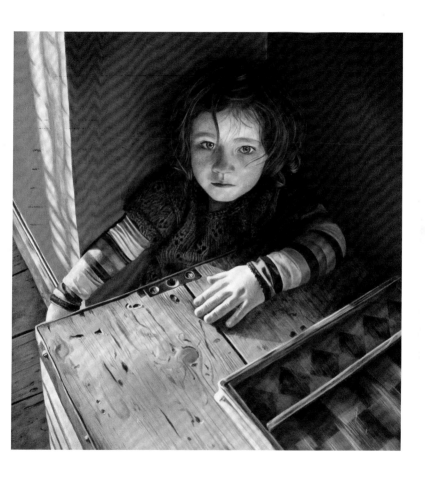

Paddy (Le Flaneur)
Nicky Philipps

Oil on canvas,
1016 x 762mm (40 x 30")

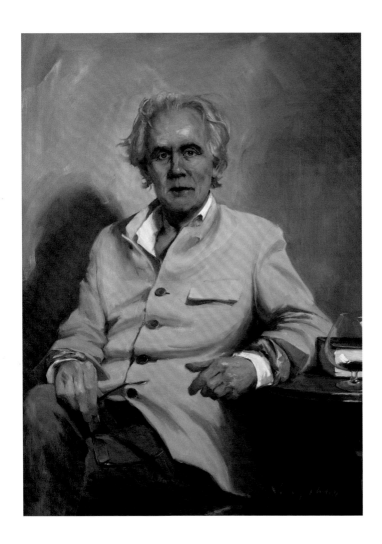

Debra
Philip Renforth

Oil on board,
1380 x 980mm (54³/₈ x 38¹/₂")

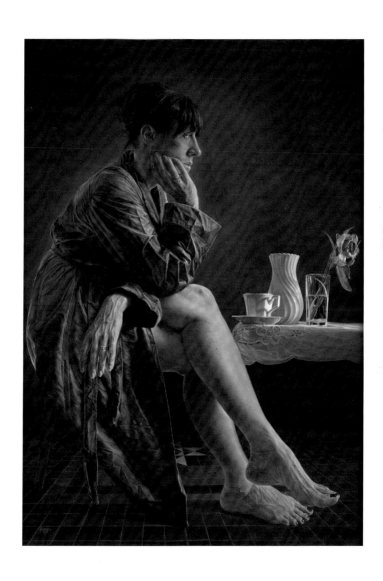

Apostolado/Apostolate
Rafael Rodríguez

Oil on wooden board,
200 x 1965mm (7⁷/₈ x 77³/₈")

Geneva
Ilaria Rosselli del Turco

Oil on wooden board,
340 x 235mm (13³/₈ x 9¹/₄")

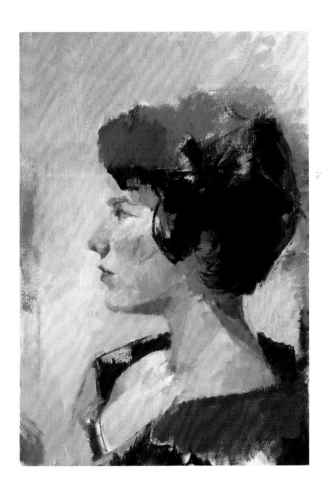

**Portrait of Giuseppe
Giampaolo Russo**

Oil on canvas,
850 x 800mm (33$^{1}/_{2}$ x 31$^{1}/_{2}$")

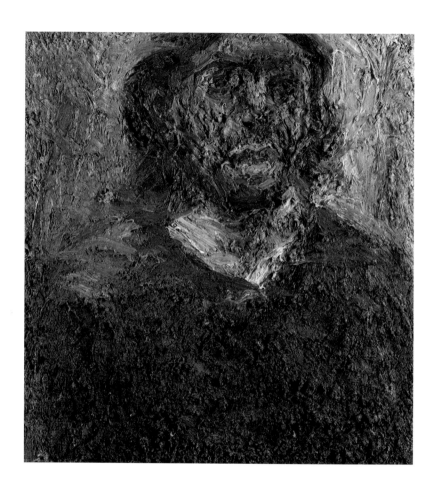

Chris, Art Critic
Fred Schley

Oil on canvas,
500 x 600mm (19$^3/_4$ x 23$^5/_8$")

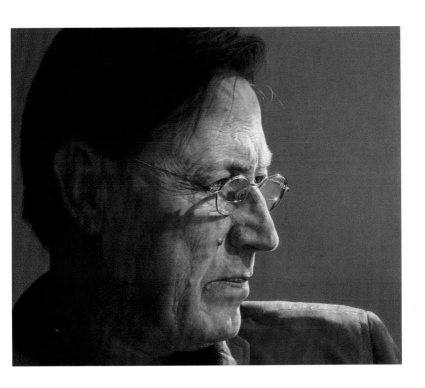

Theo
Nathalie Beauvillain Scott

Oil on canvas,
405 x 305mm (16 x 12")

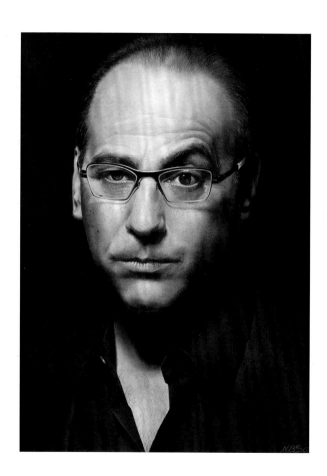

Inside Outside (Clare with Claire)
Brian Shields

Acrylic on canvas,
1180 x 730mm (46$^1/_2$ x 28$^3/_4$")

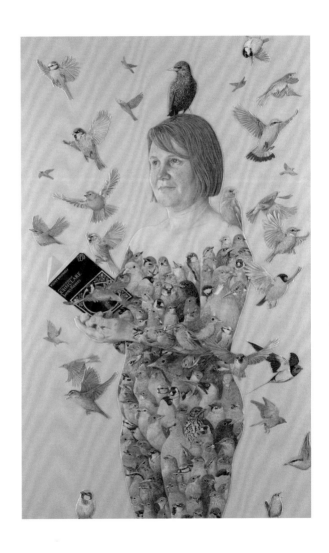

Buttery Assistant
Benjamin Sullivan

Oil on canvas,
457 x 250mm (18 x 9³/₄")

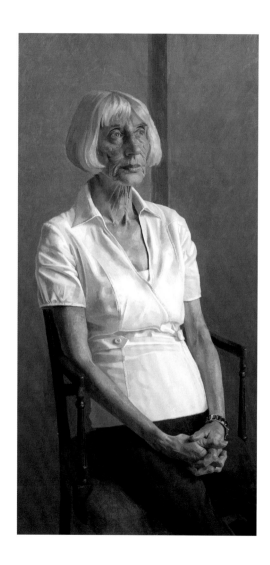

Nora
Edward Sutcliffe

Oil on canvas,
450 x 300mm (17³/₄ x 11³/₄")

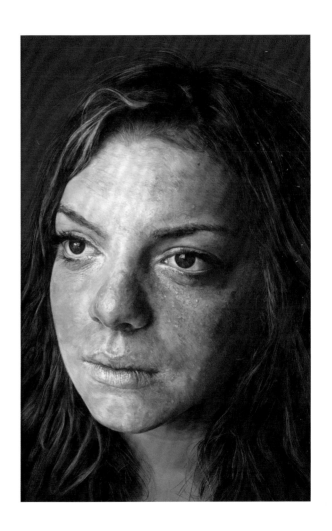

The 'Finger-Assisted' Nephrectomy
of Professor Nadey Hakim & the
World Presidents of the International
College of Surgeons in Chicago, or,
The Wise in Examination of the Torn
Contemporary State
Henry Ward

Oil on canvas,
1676 x 3048mm (66 x 120")

Eli
Antony Williams

Egg tempera on wooden board,
420 x 355mm (16$^1/_2$ x 14")

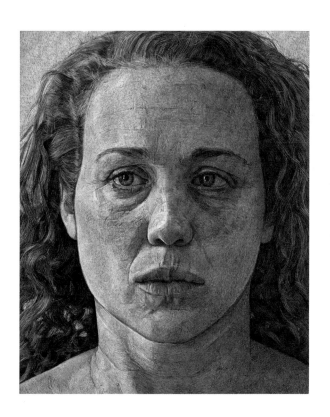

BP TRAVEL AWARD 2009

Each year exhibitors are invited to submit a proposal for the BP Travel Award. The aim of this award is to give an artist the opportunity to experience working in a different environment, in Britain or abroad, on a project related to portraiture. The artist's work is then shown as part of the following year's BP Portrait Award exhibition and tour.

THE JUDGES

Liz Rideal,
Art Resource Developer,
National Portrait Gallery

Des Violaris,
Director, UK Arts & Culture, BP

Flora Fricker,
Exhibition Manager,
National Portrait Gallery

The Prizewinner 2009
Isobel Peachey, who received £5,000 for her proposal to travel to Switzerland and Belgium to paint portraits of people engaged in historical re-enactment events.

RE-ENACTING
THE PAST

As part of the BP Travel Award 2009 I travelled to two major historical re-enactment events. Firstly, I attended the weekend occupation in June 2009 of Gruyères Castle in Switzerland by the medieval organisation The Company of Saynt George. This was followed in September 2009 with a visit to Oostmalle in Belgium, for a re-enactment of the 'forgotten battle' of Hoogstraten, a battle in January 1814 during the period leading up to Napoleon's defeat at Waterloo. I hoped that meeting, and later depicting, twenty-first-century people who had assumed historic identities would offer a new conceptual direction for my painting.

My interest in 'living history' and battle re-enactments had first been aroused when I became involved in educational workshops for children in local museums. Child-sized replicas of historical costumes and room-sets constructed to represent Tudor markets or Victorian homes were all part of the theatre for these 'living history' sessions. The children took great delight in immersing themselves in their roles as Henry VIII, market sellers or scullery maids. When the opportunity of the BP Travel Award presented itself, I proposed to deepen my experience of historical re-enactment, and find out more

about the reasons why people across Europe participate in these events outside an educational context.

At the medieval town of Gruyères, situated in the foothills of the Swiss Alps, I was joined by my childhood friend and BP Portrait Award 2009 model, Ruth Edwards. As we made our way through the quiet medieval streets at dawn, we found ourselves in front of the large wooden castle

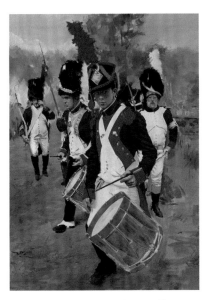

Drummers: Light Infantry Imperial Guard and Sapper, Grenadiers of the Guard, re-enactment of the Battle of Hoogstraten (work in progress) by Isobel Peachey, 2010 Oil on canvas, 700 x 500mm (27$^{1}/_{2}$ x 19$^{3}/_{4}$")

gates. Beneath the portcullis were a pair of medieval boots and the butt of a halberd: our first introduction to The Company of Saynt George. This organisation, co-founded by the historical illustrator Gerry Embleton in 1988, re-enacts the military and civil life of a Burgundian artillery unit of the 1460s and 1470s. Its pursuit of research-based 'living history', high standards of authenticity and uncompromising membership criteria attracted my interest. Members immerse themselves entirely in medieval life and allow no modern artefacts on site during the re-enactment. Food is prepared as it would have been in medieval times, and members sleep on straw mattresses in their linen shirts under their cloaks. Mornings commence with stoking the fires for breakfast and with men dressing their masters, followed by a roll-call at which the day's instructions are issued.

We were introduced to Jonas from Sweden, who wore custom-made armour that, he told us, cost a small fortune. Jonas looked at ease in his armour but explained that the role of the medieval knight was not a pleasant one and that the truth was far from the pure and honourable depiction of knights in paintings. Back in Stockholm, Jonas was a train driver, but our perception of his identity had been so profoundly shaped by our first impression that we had great difficulty imagining Jonas in his present-day role.

Over a period of three days the company re-enacted halberd and gun drills, commercial life, feasting and dancing, and a siege of the castle. At dusk on the last day, the

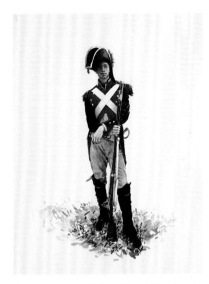

Thomas, Gendarme of the French Imperial Gendarmerie, Napoleonic encampment by Isobel Peachey, 2010 Watercolour, ink and pencil on paper, 305 x 230mm (12 x 9")

events came to a close with a procession through the castle gates to the medieval town square. In the square, before a large fire, there was dancing to music played on authentic period instruments. The gunners fired their smoky and deafening salute before the company returned to the castle and their beds.

For my second re-enactment, I arrived at a Napoleonic bivouac where I was given a press pass entitling me to access all areas. Five hundred re-enactors had constructed their regimental camps in the woods surrounding the Castle of Renesse. In a large clearing an arena had been set up for the grand re-enactments. Although this had been cordoned off, I was able to watch the building of the 'theatre': a hamlet, wooden bridges, battle-grounds and even a guillotine.

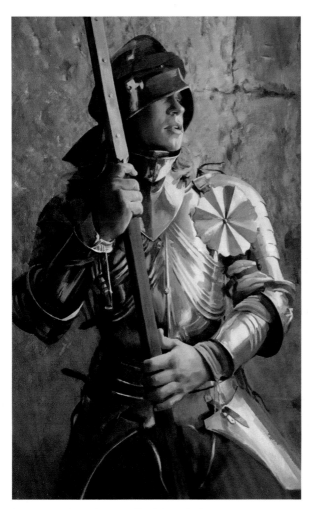

Jonas, medieval knight, Company of Saynt George (work in progress)
by Isobel Peachey, 2010
Oil on canvas, 800 x 500mm (31$\frac{1}{2}$ x 19$\frac{3}{4}$")

On my first visit to the camp I was fortunate enough to encounter Yves Moerman and his son Thomas. Yves was the officer in charge of the military parade at the memorial service in Hoogstraten and persuaded me to don period costume on the final day. Wearing Imperial Guard regalia I could enter the arena, where no other photographer was allowed, on the condition that my camera remained disguised by my cloak. Yves taught me to march in close formation, elbow-to-elbow, my only giveaway being the green Wellington boots

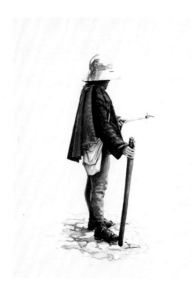

Daniel, handgunner, Company of Saynt George,
medieval re-enactment by Isobel Peachey, 2010
Watercolour, ink and pencil on paper,
305 x 230mm (12 x 9")

I was wearing! Being surrounded by rifle and cannon fire, axes, charging horses, smoke and general pandemonium was a thrilling experience, even if it was mixed with fear and apprehension.

Each of the two re-enactments ended with eager invitations to future events and promises to keep in touch. Once the public had left, the cars and vans arrived; tents were dismantled and fires left to die down. Equipment was packed, straw bedding turned out and flags lowered, and the odd bottle of beer or can of Coke appeared. I was not prepared for the surprise when the re-enactors whom I'd got to know so well seemed barely recognisable in their modern-day clothing. Halberds, rifles and cannon were exchanged for car keys and mobile phones. It

took some time for me to adjust to the twenty-first century. We said our farewells and I left them to their long journeys home to their kitchens, warm beds and showers.

Inspired in part by these experiences, I have recently decided to explore more closely the idea of identity in portrait painting. We try to determine the identity of a sitter by their outward appearance, the portrait's setting and even the style of the painting and medium used. We surmise a great deal from the surface depiction. Would it be possible, I wondered, when painting portraits of re-enactors in costume, to capture the essence of the modern person, or would the individual be completely masked by their historical character? Would I be painting the person I see as the artist, or the person the sitter wishes to be portrayed?

My BP Travel Award project would not have been possible without the assistance and warm welcome I received from the many re-enactors I met, as well as from their respective organisations. It would be impossible to list all the people who gave so freely of their time and received me into their circle, recounting at length who they were, detailing the historic, military and social context in which they had immersed themselves. However, among the many there are some whose support and guidance was crucial to the completion of my project – Gerry Embleton, Christian Follini, Thomas Rauber at Gruyères and Ron Van Dyke and Yves Moerman at Oostmalle.

Isobel Peachey

ACKNOWLEDGEMENTS

My first thanks go, as ever, to all the artists who decided to enter the 2010 Award. Congratulations go to all the artists included in the exhibition, with particular praise for the prize winners, Daphne Todd, Michael Gaskell and David Eichenberg, and to Elizabeth McDonald, the winner of the prize for a younger painter.

Thanks go to my fellow judges: Sarah Howgate, Ishbel Myerscough, Christine Rew, Sir David Scholey and Des Violaris. They were thoroughly attentive to the large number of entries, and were both generous and determined throughout the selection process. I am also grateful to the judges of the BP Travel Award: Liz Rideal, Des Violaris and Flora Fricker. I would like to offer particular thanks to Rose Tremain for her fascinating catalogue essay, which links her own life and ideas with portrait painting. I am very grateful to Robert Davies for his editorial work, Anne Sørensen for her design work on the catalogue and also to Flora Fricker for her creative management of the 2010 BP Portrait Award exhibition. My thanks also go to Pim Baxter, Claudia Bloch, Neil Evans, Ian Gardner, Natalia Calvocoressi, Michelle Greaves, Celia Joicey, Justine McLisky, Ruth Müller-Wirth, Doris Pearce, Jonathan Rowbotham, Jude Simmons, Liz Smith, Christopher Tinker, Sarah Tinsley, and other colleagues at the National Portrait Gallery for all their hard work in making the project such a continuing success. My thanks go to the white wall company for their contribution during the selection and judging process.

Sandy Nairne
Director, National Portrait Gallery

Picture Credits
All works copyright © the Artist, except for page 7: © National Portrait Gallery, London; page 9: Given by the photographer's sister, Susan Morton, 1976 © William Hustler and Georgina Hustler / National Portrait Gallery, London; page 11: © Derry Moore; page 12: Given by Delmar Banner, 1948 © National Portrait Gallery, London.

INDEX

Ansell, Mary Jane 20
Auden, W.H. 10
Avancini, Annalisa 21

Bagnall, Robin 22
Banner, Delmar, *Beatrix Potter* 11–12, *12*
Beel, Paul 23
Bennett, Alan 10–11, *11*
Benney, Paul 24
Berg, Shany van den 25
Blum, Maître Suzanne 9
Burnett, Oscar 26
Butler, Jason 27

Charles II, King 7–8, 10
Coffield, Darren 28
The Company of Saynt George 75–6
Coulson, Alan 29
Cross, Richard 30

Dewhurst, Tom 31
Dipré, David 32
Dougherty, Anna 33
Downey, Shaun 34

Edwards, Ruth 75
Eichenberg, David 17 (Third Prize)
Elia, Wendy 35
Embleton, Gerry 76
Enkauoa, Daniel 36
Escofet, Miriam 37

Ford, Nathan 38
Foroozanfar, Maryam 39

Gaskell, Michael 16 (Second Prize)
Gruyères Castle, Switzerland 75–6

Haigh, Eliot 40
Hanke, Bruce 41
Hanna, Alex 42
Harper, Jason 43
Hayls, John, *Samuel Pepys* 67
Heldens, Wim 44
Hodges, Kaye 45
Hoogstraaten 77

Jameson, Lyndsey 47
Jameson, Mark 46
Jonas 76, 77

Kelley, Diarmuid 48

Lamb, Rosy 49
Layzell, Peter 50

McDonald, Elizabeth *18* (BP Young Artist Award)
Martinez, Raoul *51*
Masacz, Helen *52*
Melling, George 53
Moerman, Yves and Thomas 77
Moore, Derry, *Alan Bennett* 10–11, *11*
Moya, Miguel Angel 54
Muro, Carlos 55

Nason, Pieter 8
Nightingale, David 56
Noble, Tony *57*

Ogbebor, Benjamin 58
Okamura, Tim 59
Oostmalle, Belgium 75
Ožibko, Mikhal 60

Peachey, Isobel 75–8
 Daniel, handgunner, Company of Saynt George 78
 Drummers: Light Infantry Imperial Guard and Sapper, Grenadiers of the Guard 75
 Jonas, medieval knight, Company of Saynt George 77
 Thomas, Gendarme of the French Imperial Gendarmerie 76
Penna, Thea *61*
Pepys, Samuel 6–7
Philipps, Nicky 62

Renesse, Castle of 76–8
Renforth, Philip 63
Rodríguez, Rafael 64
Rosselli del Turco, Ilaria 65
Russo, Giampaolo 66

Schley, Fred *67*
Scott, Nathalie Beauvillain 68
Shields, Brian 69
Sullivan, Benjamin 70
Sutcliffe, Edward *71*

Todd, Daphne 15 (First Prize)
Tremain, Rose
 The Darkness of Wallis Simpson 9–10
 Restoration 8–9

Ward, Henry 72
Wilding, Dorothy, *Wallis, Duchess of Windsor* 9
Williams, Antony 73
Windsor, Edward, Duke of 10
Windsor, Wallis Simpson, Duchess of 9–10, 12